THROUGH A CAT'S EYES

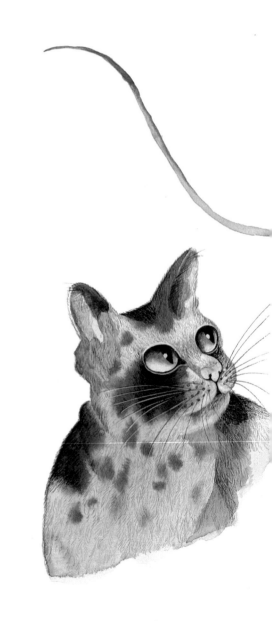

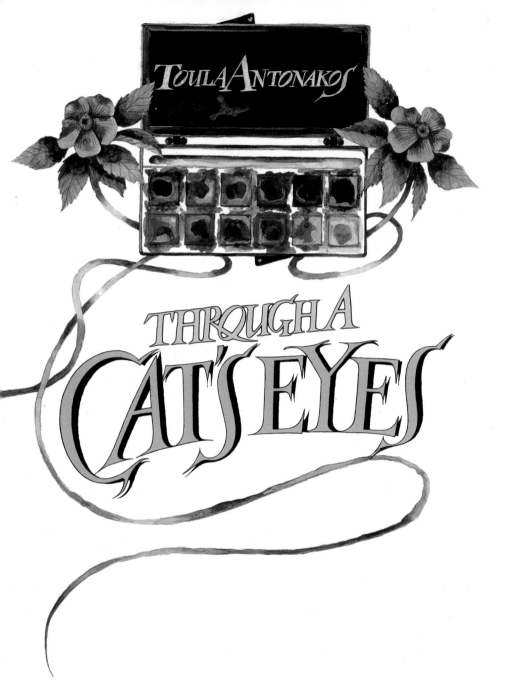

TOULA ANTONAKOS

THROUGH A CAT'S EYES

SIDGWICK & JACKSON
L·O·N·D·O·N

First published in 1988 by
Sidgwick & Jackson Limited
1 Tavistock Chambers, Bloomsbury Way
London, WC1A 2SG

ISBN 0 283 99585 8

Originated in Hong Kong by South Seas
Printed in Great Britain by Maclehose and Partners

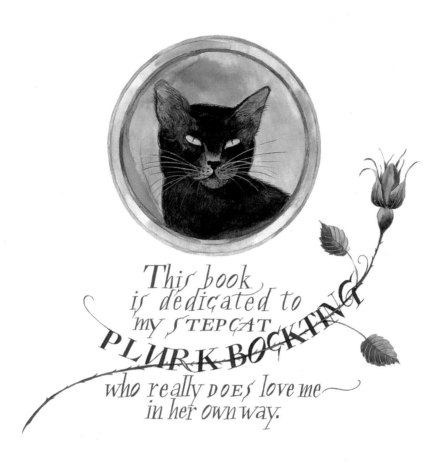

This book
is dedicated to
my STEPCAT
PLURK BOCKING
who really DOES love me
in her own way.

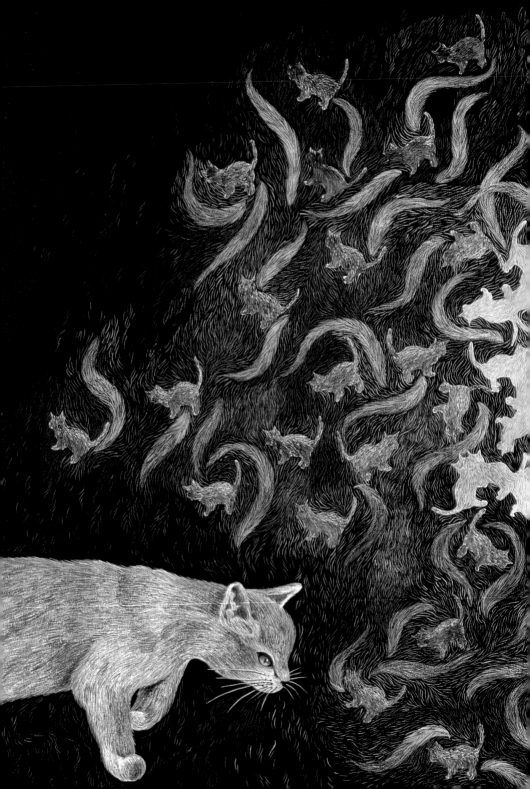

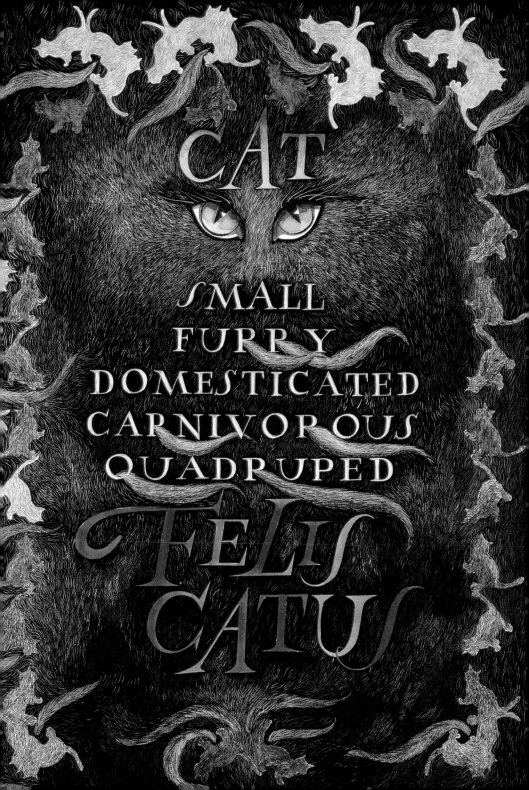

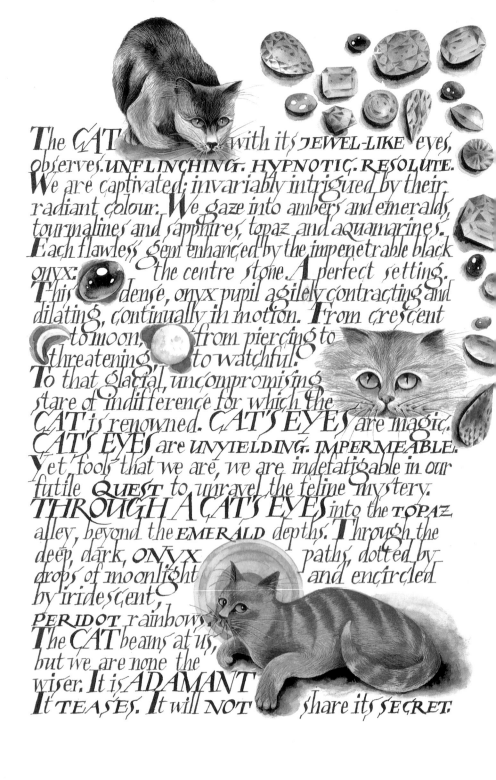

The CAT with its JEWEL-LIKE eyes, observes. UNFLINCHING. HYPNOTIC. RESOLUTE. We are captivated; invariably intrigued by their radiant colour. We gaze into ambers and emeralds, tourmalines and sapphires, topaz and aquamarines. Each flawless gem enhanced by the impenetrable black onyx: the centre stone. A perfect setting. This dense, onyx pupil agilely contracting and dilating, continually in motion. From crescent to moon, from piercing to threatening to watchful. To that glacial, uncompromising stare of indifference for which the CAT is renowned. CAT'S EYES are magic. CAT'S EYES are UNYIELDING. IMPERMEABLE. Yet, fools that we are, we are indefatigable in our futile QUEST to unravel the feline mystery. THROUGH A CAT'S EYES into the TOPAZ alley, beyond the EMERALD depths. Through the deep, dark, ONYX paths, dotted by drops of moonlight and encircled by iridescent, PERIDOT rainbows. The CAT beams at us, but we are none the wiser. It is ADAMANT It TEASES. It will NOT share its SECRET.

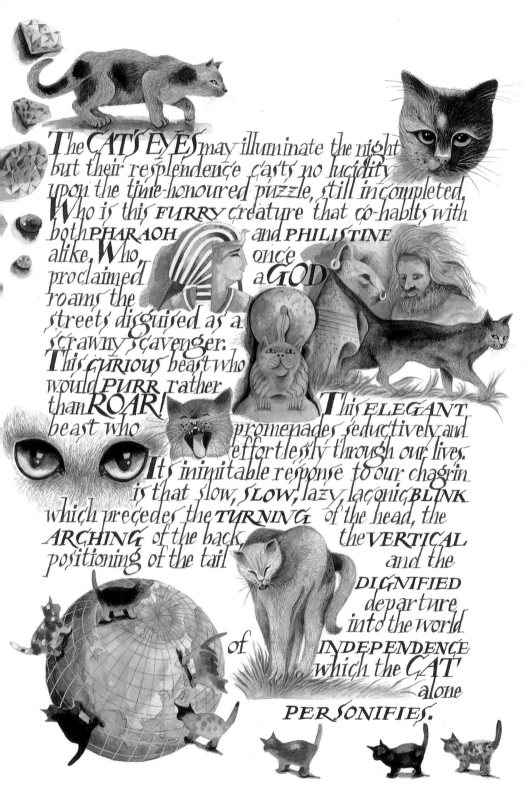

The CAT'S EYES may illuminate the night but their resplendence casts no lucidity upon the time-honoured puzzle, still incompleted. Who is this FURRY creature that co-habits with both PHARAOH and PHILISTINE alike. Who once proclaimed a GOD roams the streets disguised as a scrawny scavenger. This CURIOUS beast who would PURR rather than ROAR! beast who promenades seductively and effortlessly through our lives. This ELEGANT Its inimitable response to our chagrin is that slow, SLOW, lazy, laconic BLINK which precedes the TURNING of the head, the ARCHING of the back, the VERTICAL positioning of the tail and the DIGNIFIED departure into the world of INDEPENDENCE which the CAT alone PERSONIFIES.

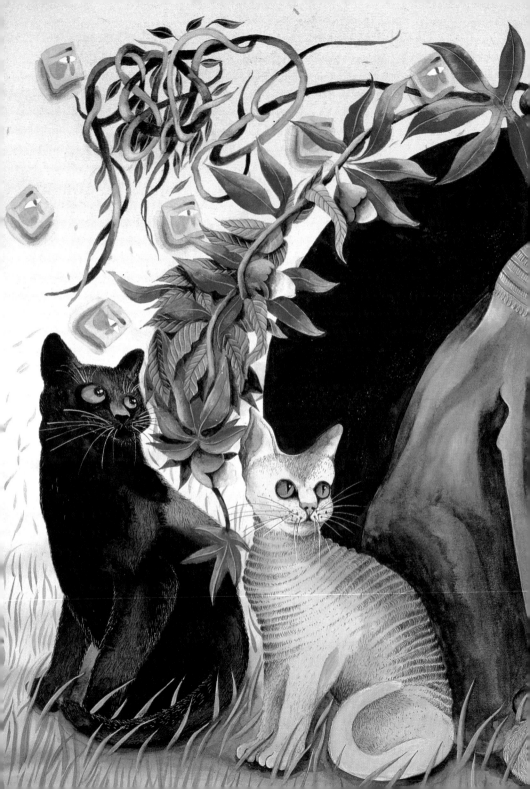

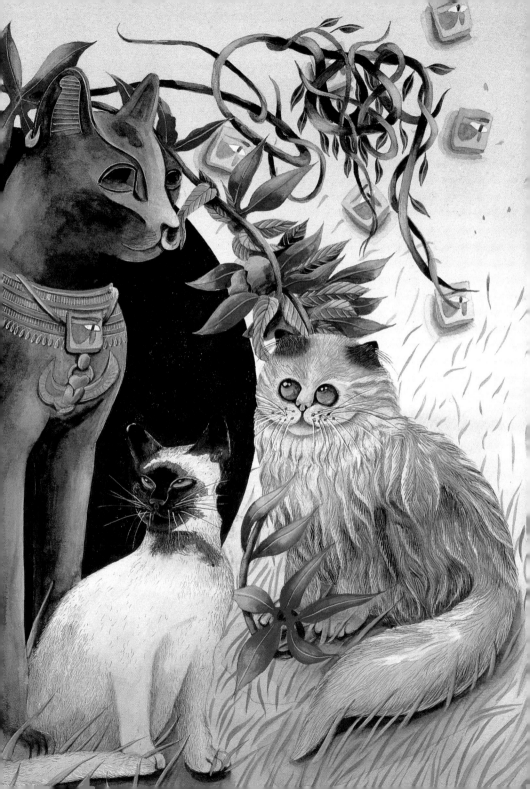

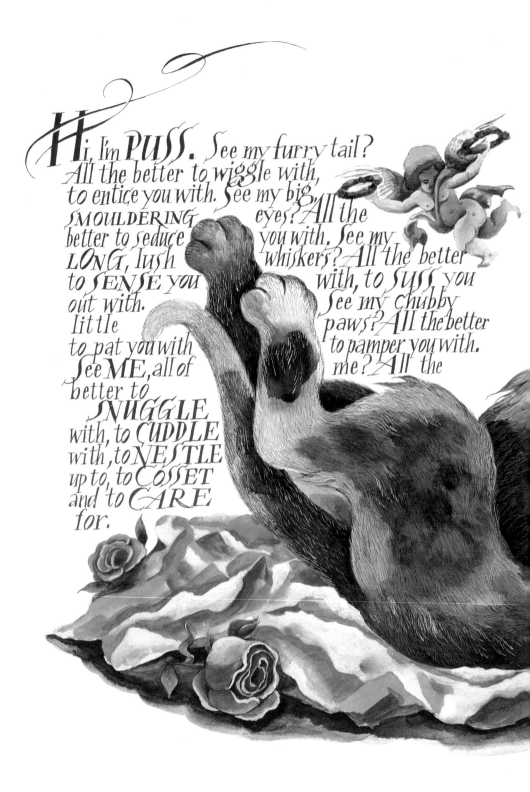

Hi, I'm PUSS. See my furry tail? All the better to wiggle with, to entice you with. See my big, SMOULDERING eyes? All the better to seduce you with. See my LONG, lush whiskers? All the better to SENSE you with, to SUSS you out with. See my chubby little paws? All the better to pat you with, to pamper you with. See ME, all of me? All the better to SNUGGLE with, to CUDDLE with, to NESTLE up to, to COSSET and to CARE for.

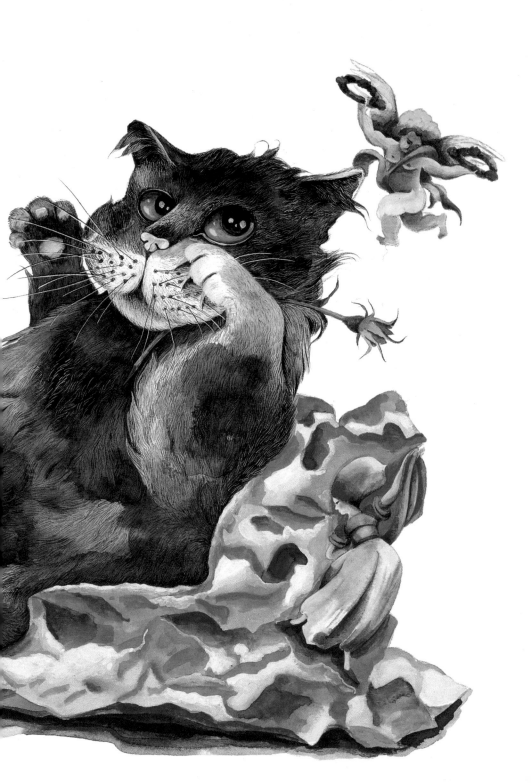

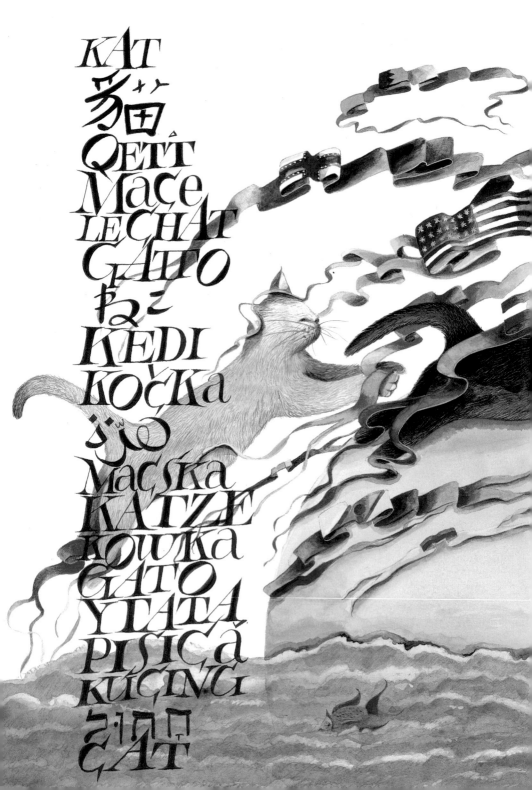

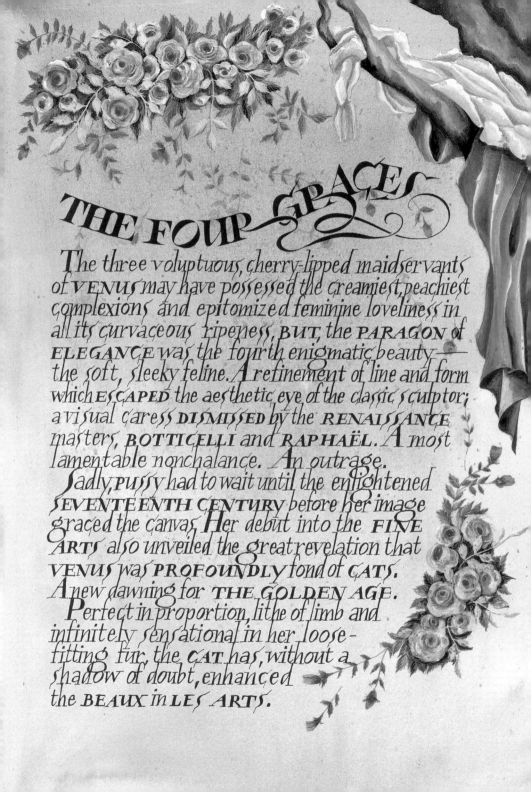

THE FOUR GRACES

The three voluptuous, cherry-lipped maidservants of VENUS may have possessed the creamiest, peachiest complexions and epitomized feminine loveliness in all its curvaceous ripeness, BUT, the PARAGON of ELEGANCE was the fourth enigmatic beauty — the soft, sleeky feline. A refinement of line and form which ESCAPED the aesthetic eye of the classic sculptor; a visual caress DISMISSED by the RENAISSANCE masters, BOTTICELLI and RAPHAËL. A most lamentable nonchalance. An outrage.

Sadly, pussy had to wait until the enlightened SEVENTEENTH CENTURY before her image graced the canvas. Her debut into the FINE ARTS also unveiled the great revelation that VENUS was PROFOUNDLY fond of CATS. A new dawning for THE GOLDEN AGE.

Perfect in proportion, lithe of limb and infinitely sensational in her loose-fitting fur, the CAT has, without a shadow of doubt, enhanced the BEAUX in LES ARTS.

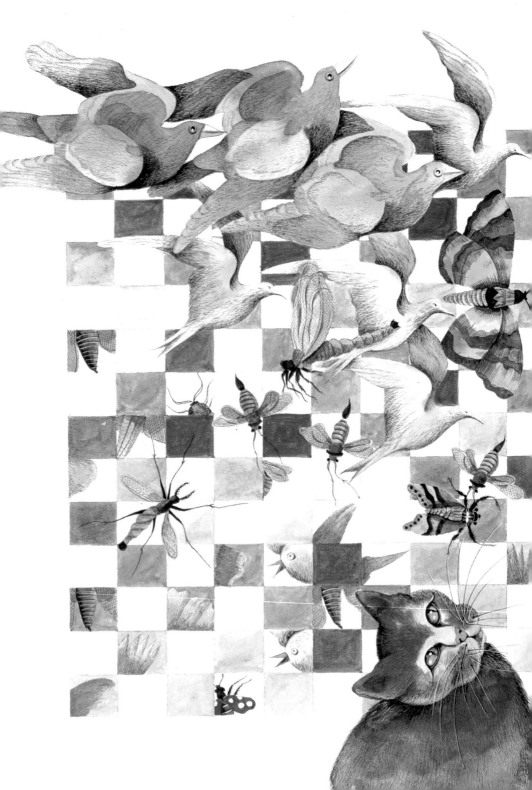

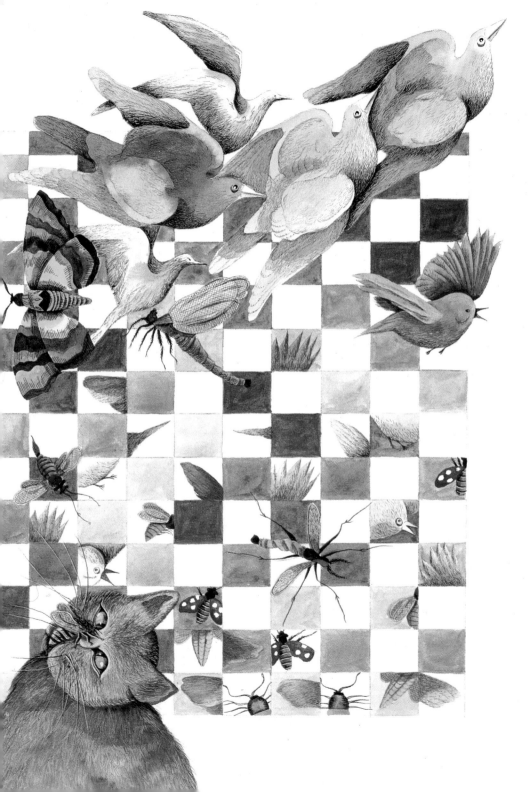

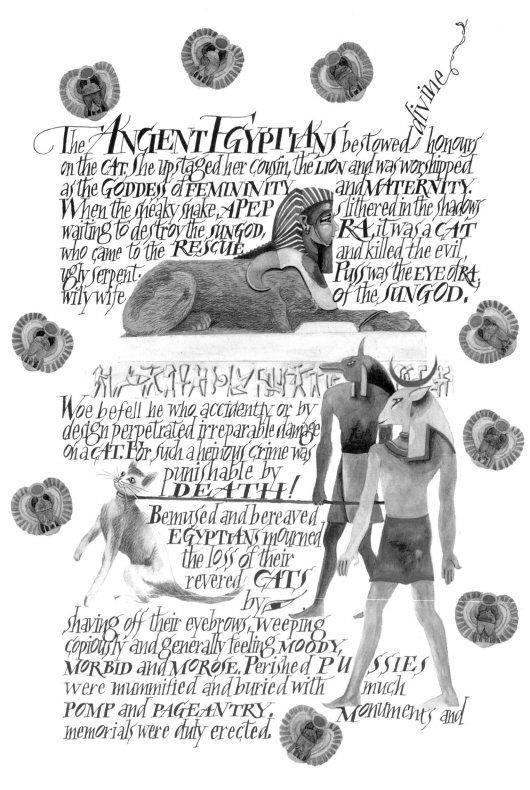

The ANCIENT EGYPTIANS bestowed divine honours on the CAT. She upstaged her cousin, the LION and was worshipped as the GODDESS of FEMININITY and MATERNITY. When the sneaky snake, APEP slithered in the shadows waiting to destroy the SUNGOD, RA, it was a CAT who came to the RESCUE and killed the evil, ugly serpent. Puss was the EYE of RA, wily wife of the SUNGOD.

Woe befell he who accidently or by design perpetrated irreparable damage on a CAT. For such a heinous crime was punishable by DEATH!

Bemused and bereaved EGYPTIANS mourned the loss of their revered CATS by shaving off their eyebrows, weeping copiously and generally feeling MOODY, MORBID and MOROSE. Perished PUSSIES were mummified and buried with much POMP and PAGEANTRY. Monuments and memorials were duly erected.

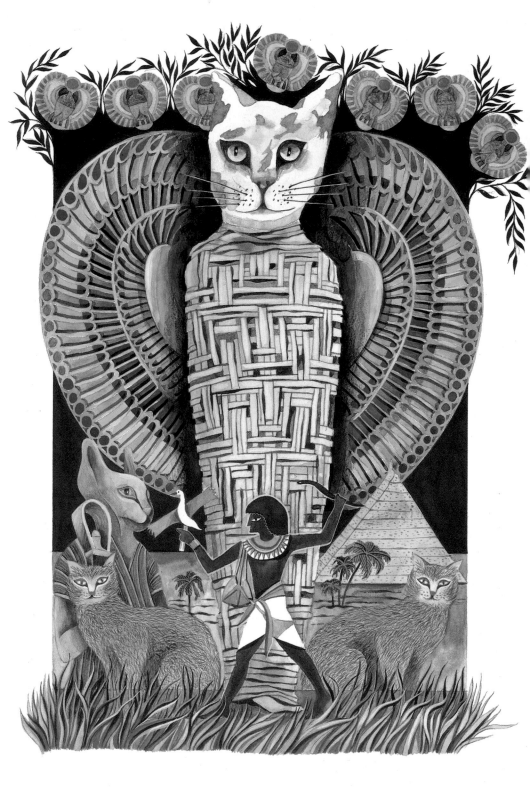

An elegant panatella, a box of creamy Belgian bon bons and a bunch of red, red roses by the bedside of an aging VEDETTE DU CINÉMA. Here in the celebrity suite on the 52nd floor of the HOTEL WISTERIA, poised in supine splendour, LA BELLE BLANCHE and her indolent darlings cohabit in symbiotic snugness. Weaned on caviare, champagne, truffels vol-au-vent and fish sticks, LES TROIS CHATS FORMIDABLES are irrevocably accustomed to luxury and excesses of ANY KIND. SO insufferably SMUG, SO overtly conceited, they devote much time to prolonged and lingering ablutions, meticulous grooming and the general BEAUTIFICATION of the person — to CARESS the EYE of the BEHOLDER

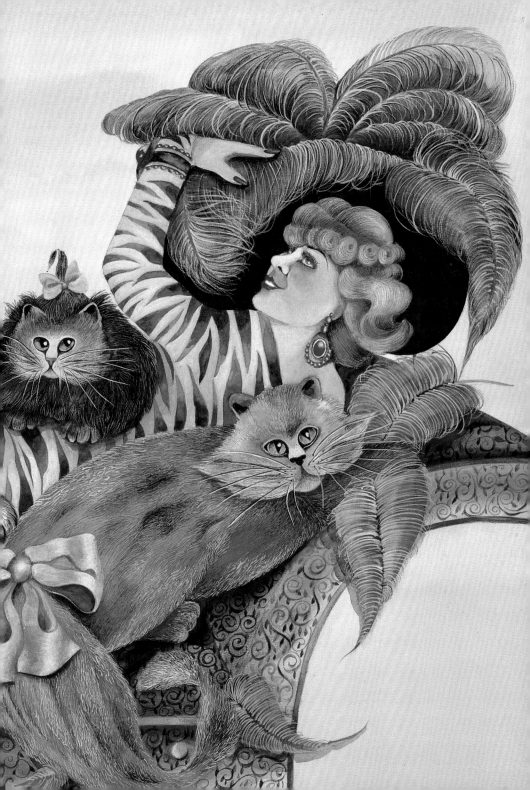

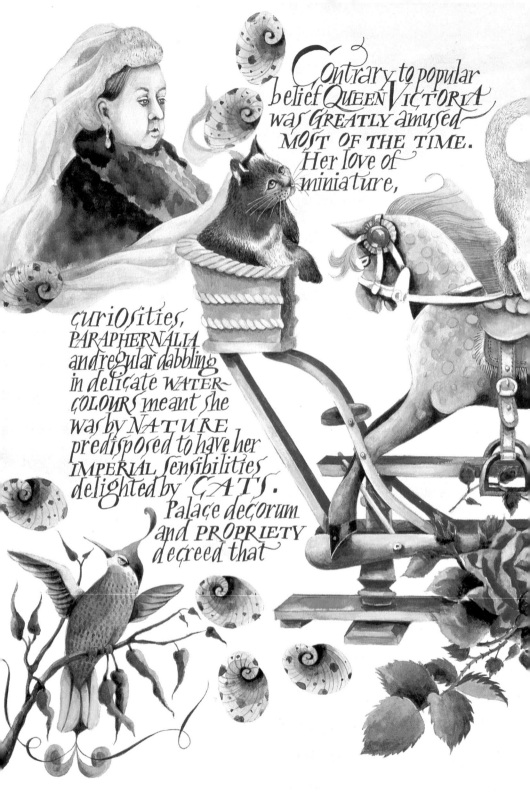

Contrary to popular belief QUEEN VICTORIA was GREATLY amused MOST OF THE TIME. Her love of miniature, curiOsities, PARAPHERNALIA and regular dabbling in delicate WATER~ COLOURS meant she was by NATURE predisposed to have her IMPERIAL sensibilities delighted by CATS. Palace decorum and PROPRIETY decreed that

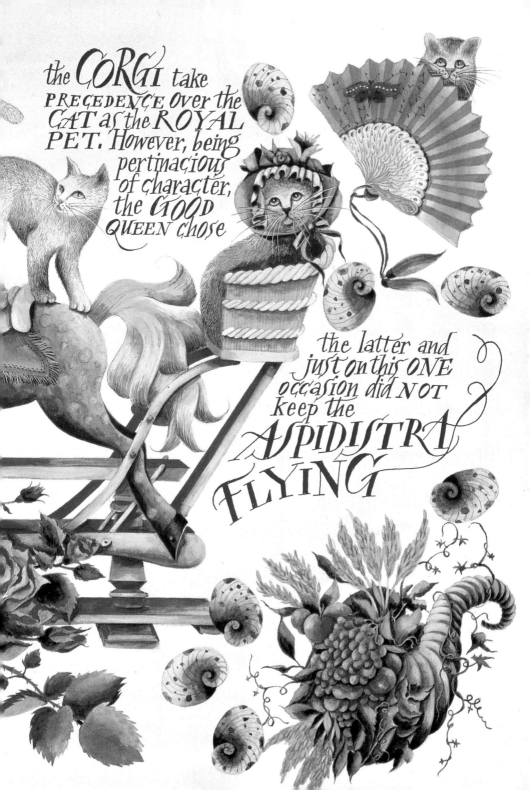

the CORGI take PRECEDENCE over the CAT as the ROYAL PET. However, being pertinacious of character, the GOOD QUEEN chose

the latter and just on this ONE occasion did NOT keep the ASPIDISTRA FLYING

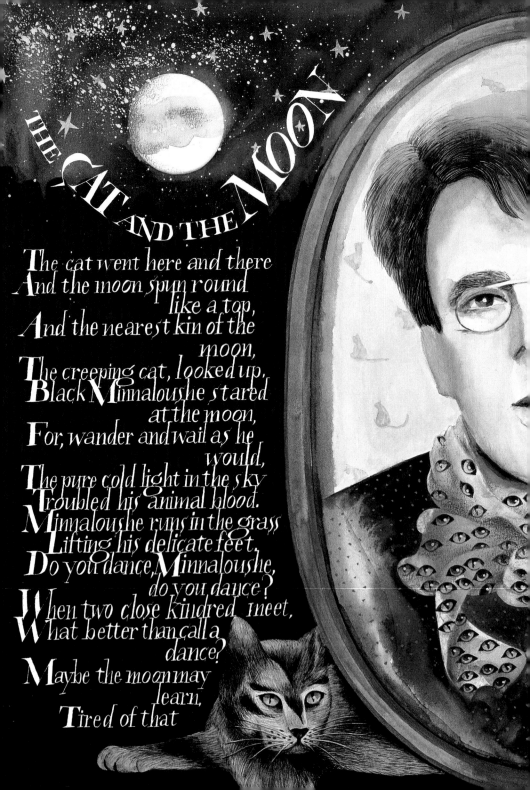

THE CAT AND THE MOON

The cat went here and there
And the moon spun round
 like a top,
And the nearest kin of the
 moon,
The creeping cat, looked up.
Black Minnaloushe stared
 at the moon,
For, wander and wail as he
 would,
The pure cold light in the sky
Troubled his animal blood.
Minnaloushe runs in the grass
 Lifting his delicate feet.
Do you dance, Minnaloushe,
 do you dance?
When two close kindred meet,
What better than call a
 dance?
Maybe the moon may
 learn,
 Tired of that

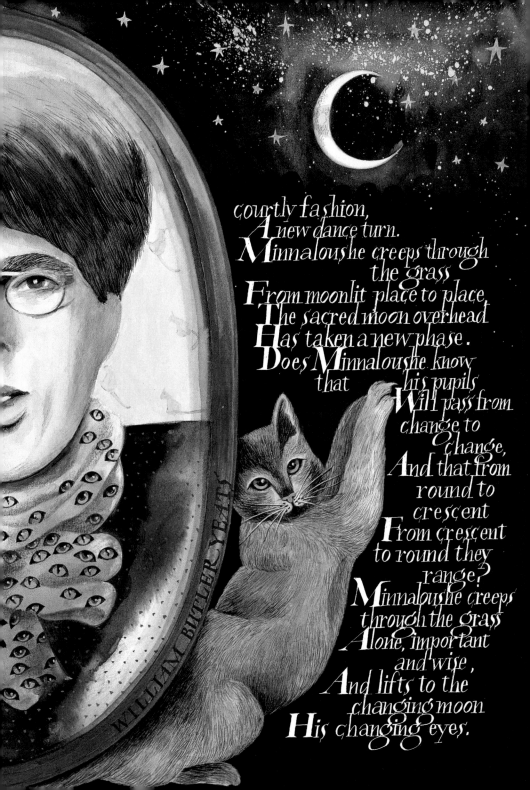

courtly fashion,
A new dance turn.
Minnaloushe creeps through
 the grass
From moonlit place to place.
The sacred moon overhead
Has taken a new phase.
Does Minnaloushe know
 that his pupils
 Will pass from
 change to
 change,
 And that from
 round to
 crescent
 From crescent
 to round they
 range?
Minnaloushe creeps
 through the grass
Alone, important
 and wise,
 And lifts to the
 changing moon
His changing eyes.

WILLIAM BUTLER YEATS

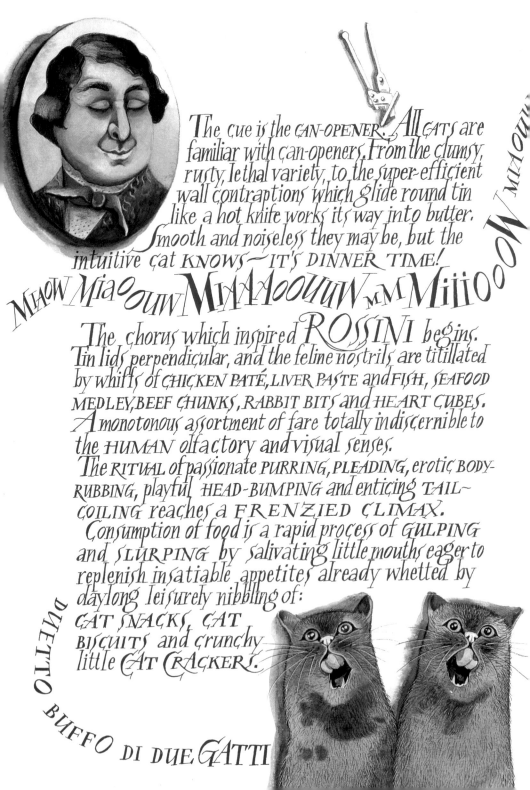

The cue is the CAN-OPENER. All CATS are familiar with can-openers. From the clumsy, rusty, lethal variety, to the super-efficient wall contraptions which glide round tin like a hot knife works its way into butter. Smooth and noiseless they may be, but the intuitive cat KNOWS — IT'S DINNER TIME!

MIAOW MiaOOUW MiAAOOUUW MM MiiiOOOUUW MIAOW

The chorus which inspired ROSSINI begins. Tin lids perpendicular, and the feline nostrils are titillated by whiffs of CHICKEN PATÉ, LIVER PASTE and FISH, SEAFOOD MEDLEY, BEEF CHUNKS, RABBIT BITS and HEART CUBES. A monotonous assortment of fare totally indiscernible to the HUMAN olfactory and visual senses.

The RITUAL of passionate PURRING, PLEADING, erotic BODY-RUBBING, playful HEAD-BUMPING and enticing TAIL-COILING reaches a FRENZIED CLIMAX.

Consumption of food is a rapid process of GULPING and SLURPING by salivating little mouths eager to replenish insatiable appetites already whetted by daylong leisurely nibbling of:
CAT SNACKS, CAT BISCUITS and crunchy little CAT CRACKERS.

DUETTO BUFFO DI DUE GATTI

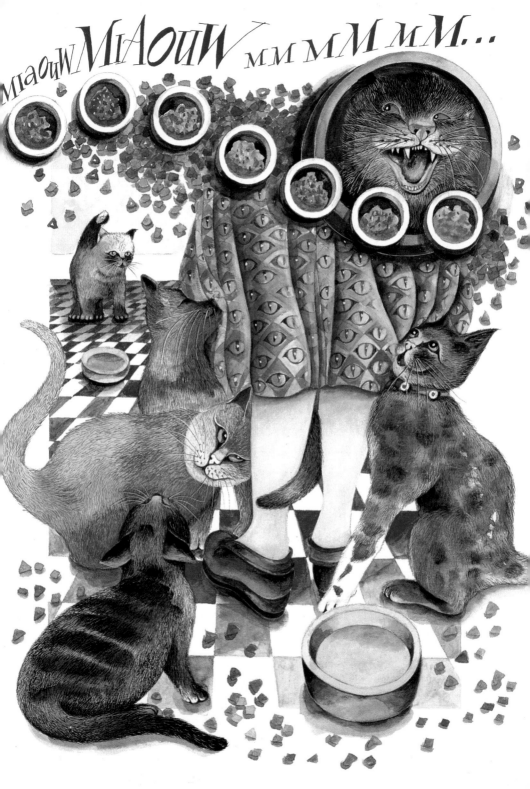

Take an Ordinary blanket of an Ordinary colour and an Ordinary texture and it is highly likely that PUSS will leave it unsoiled, unruffled and untouched. Take your most treasured Quilt of KALEIDOSCOPE

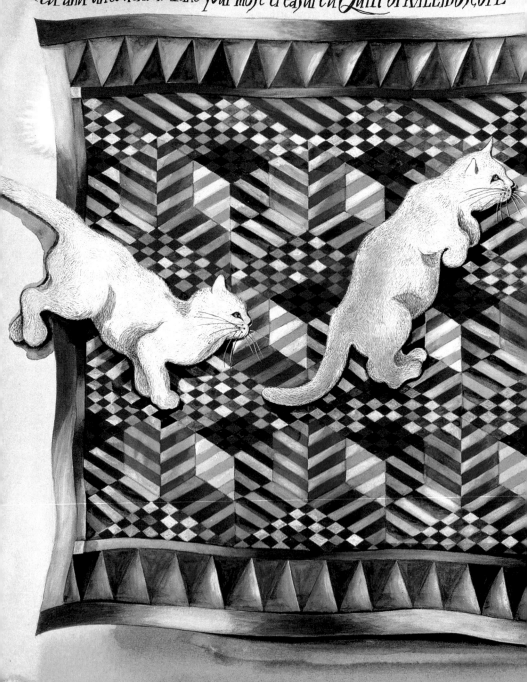

colours created by skilful hands adept in century old traditions and watch its smooth satin fabric fray with CAT CALLISTHENICS, torpid slumbers, and feline frivolities of a heartbreakingly destructive nature.

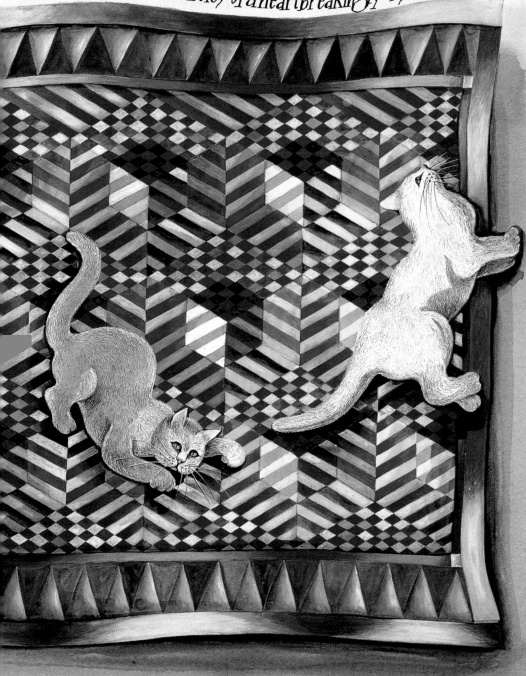

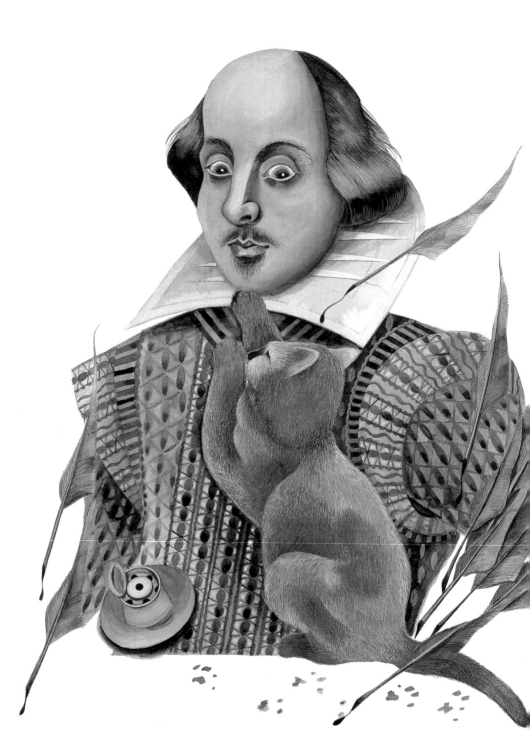

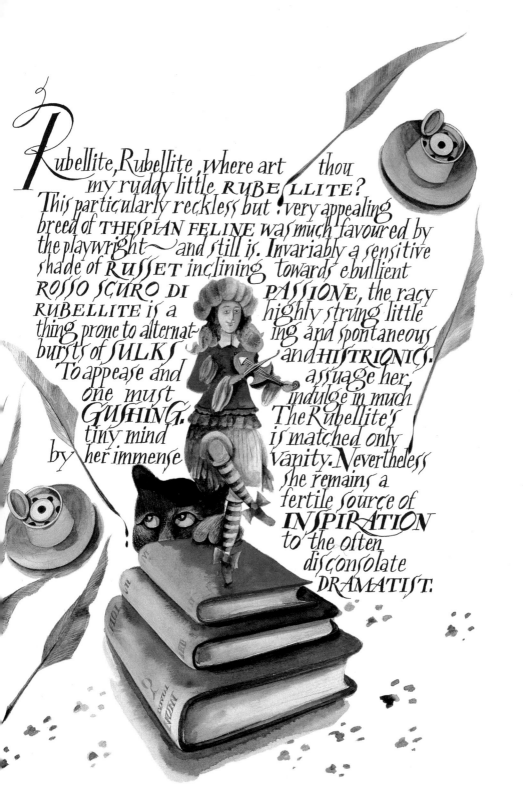

Rubellite, Rubellite, where art thou
my ruddy little RUBELLITE?
This particularly reckless but very appealing
breed of THESPIAN FELINE was much favoured by
the playwright—and still is. Invariably a sensitive
shade of RUSSET inclining towards ebullient
ROSSO SCURO DI PASSIONE, the racy
RUBELLITE is a highly strung little
thing prone to alternat-ing and spontaneous
bursts of SULKS and HISTRIONICS.
To appease and assuage her,
one must indulge in much
GUSHING. The Rubellite's
tiny mind is matched only
by her immense vanity. Nevertheless
she remains a
fertile source of
INSPIRATION
to the often
disconsolate
DRAMATIST.

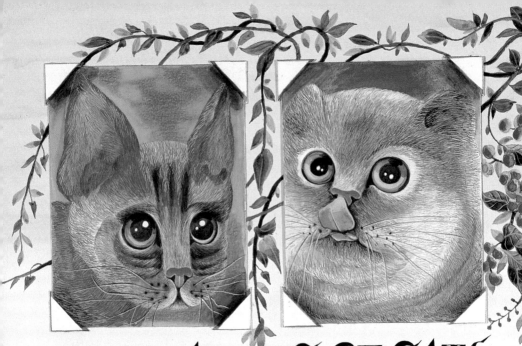

THE NAMING OF CATS

The naming of CATS is a
 difficult matter,
It isn't just one of your
 holiday games;
You may think at first I'm
 as mad as a hatter
When I tell you, a CAT must
have THREE DIFFERENT
 NAMES.
First of all, there's the name
 that the family use daily,
Such as PETER, AUGUSTUS,
 ALONZO or JAMES,
Such as VICTOR or
 JONATHAN, GEORGE
 or BILL BAILEY——

All of them sensible
 everyday names.
There are fancier names if
you think they sound sweeter,
Some for the gentlemen,
 some for the dames:
Such as PLATO, ADMETUS,
ELECTRA, DEMETER—
But all of them sensible
 everyday names.
But I tell you, a CAT needs
 a name that's particular,
A name that's peculiar,
 and more dignified,
Else how can he keep up
 his tail perpendicular,

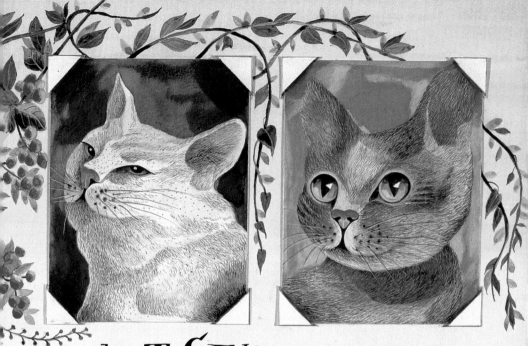

... by T. S. Eliot

Or spread out his whiskers,
 or cherish his pride?
Of names of this kind, I
 can give you a quorum.
Such as MUNKUSTRAP,
QUAXO, or CORICOPAT,
Such as BOMBALURINA,
or else JELLYLORUM—
Names that never belong
 to more than one CAT.
But above and beyond
there's still one name left over
And that is the name that
 you never will guess;
The name that no human
research can discover—

But THE CAT HIMSELF
KNOWS, and never will
 confess.
When you notice a CAT
in profound meditation,
The reason, I tell you, is
 always the same:
His mind is engaged in a
 rapt contemplation
Of the thought, of the
 thought,
of the thought of his name:
His ineffable effable
Effanineffable
Deep and inscrutable
 singular NAME.

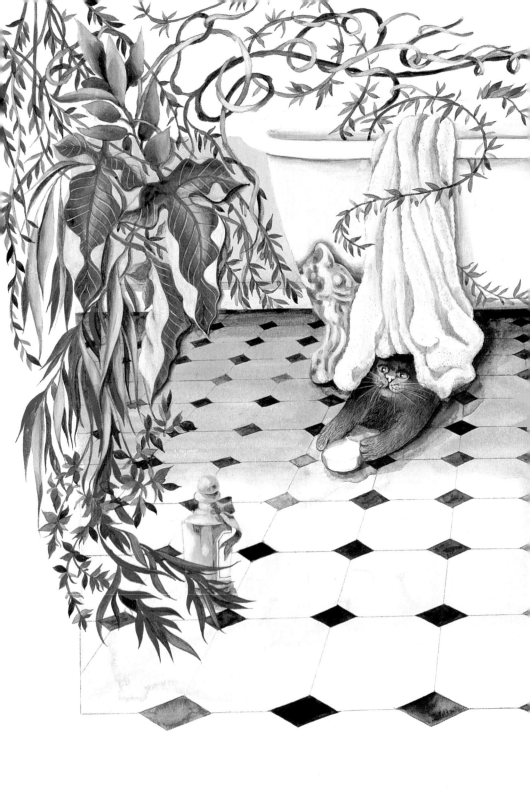

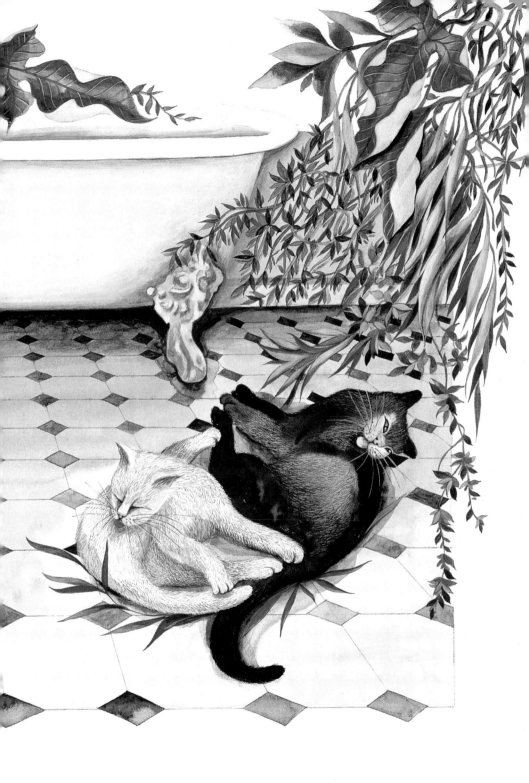

Antique, contemporary, designer, makeshift — any type of furniture will do. The CAT'S criterion in making his choice of, CHAIR, for instance — for they do settle on top of wardrobes and tables; under beds, inside kitchen cupboards and chests of drawers — is whether or not it is the one which has long been established as, YOUR FAVOURITE. That's when the battle of wills begins and NEVER ends. BRUTE FORCE is known to be adopted as a means of regaining TERRITORIAL GROUND. Cats also have a remarkably short memory for any past DISCIPLINARY action, like: NO FRUITS DE MER DELI SNACKS FOR 1 SOLID WEEK. CATS have NO concept of AUTHORITY; are ignorant of the laws pertaining to the RIGHT of OWNERSHIP; insensitive to VERBAL ABUSE and INFURIATINGLY indifferent toward your: HAVING NO PLACE TO SIT. Cats are by nature inconsiderate. What to do? GIVE UP.

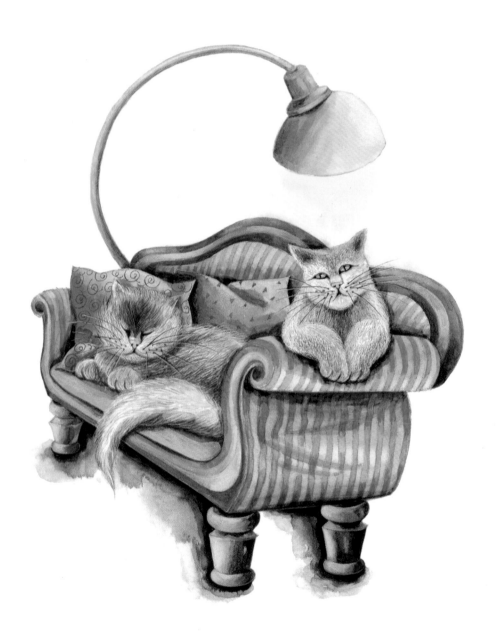

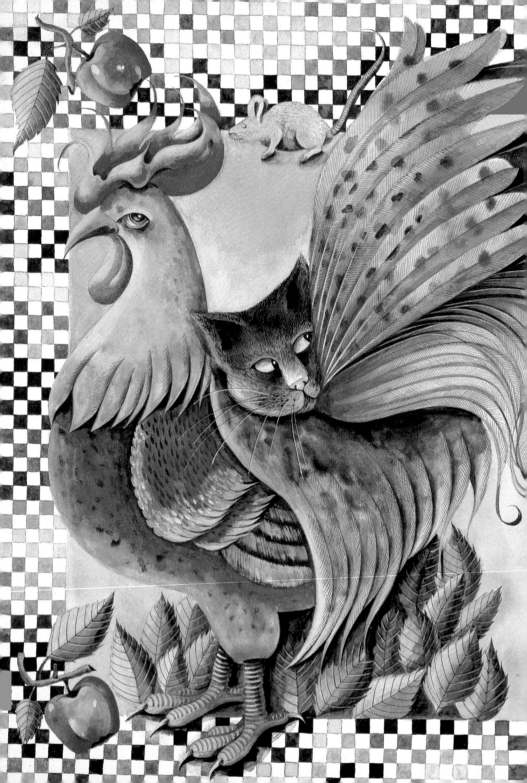

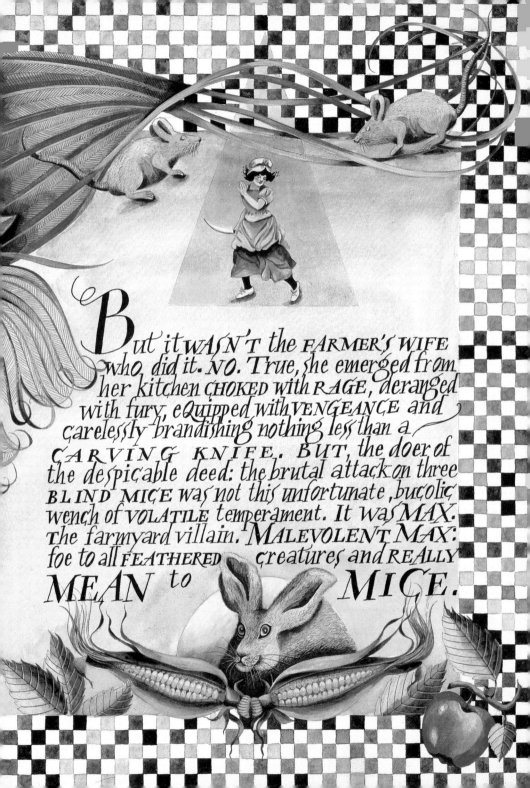

But it WASN'T the FARMER'S WIFE who did it. NO. True, she emerged from her kitchen CHOKED with RAGE, deranged with fury, eQuipped with VENGEANCE and carelessly brandishing nothing less than a CARVING KNIFE. BUT, the doer of the despicable deed: the brutal attack on three BLIND MICE was not this unfortunate, bucolic wench of VOLATILE temperament. It was MAX. the farmyard villain. MALEVOLENT MAX: foe to all FEATHERED creatures and REALLY MEAN to MICE.

The normally LOQUACIOUS, parakeet took on an uncharacteristically TACITURN demeanour causing growing suspicion that it was withholding CRUCIAL information. SASHA, the most elegant of CATS, had disappeared. SUDDENLY. Her unfortunate condition, as a result of a SHORT but HIGHLY-CHARGED infatuation with COSMO the WOMANIZER, transformed her from a female of SLEEK, PROUD bearing to a bloated, shapeless bundle suffering from WATER RETENTION and a staggering rise in BLOOD PRESSURE. Anxiety as to her delicate condition and mysterious whereabouts rose to a DISTURBING level and a SEARCH PARTY was summoned. The flower-beds were checked. The window-boxes inspected. The wine cellar scanned with a SCRUTINIZING eye. The toolshed and broom cupboard investigated; the NEIGHBOURHOOD questioned and the DOG-OWNER next door CROSS-EXAMINED. Every nook and cranny was PEERED into, no cushion was left unturned. All mounted to ZILCH. Not a TRACE of SASHA'S

lovable face. A unanimous decision was taken to adopt a more CLINICAL attitude and attribute it all to PRENATAL PERIPATETIC QUIRKINESS, thus mitigating the severity of the situation and the impending gloom about to descend. Besides, how far can a CAT GO on SWOLLEN feet? The household retired for the night. Sometime later, the URGENT need of an extension cord demanded a trip to the attic. An out-of-bounds area due to indescribable mess, chaos, accumulation of junk and space of the ACUTELY CLAUSTROPHOBIC kind. A situation presenting no major stumbling block for SASHA who was found in an old CARDBOARD REMOVAL BOX trying to feed, comfort, wash and generally organise a ridiculous number of PROGENY. She was brought downstairs—box and all— and settled on a big BRASS BED where she could REFLECT on the EPHEMERAL nature of LOVE, the DIRE consequences thereof, and the BOREDOM and BONDAGE of POSTNATAL DEBILITATION.

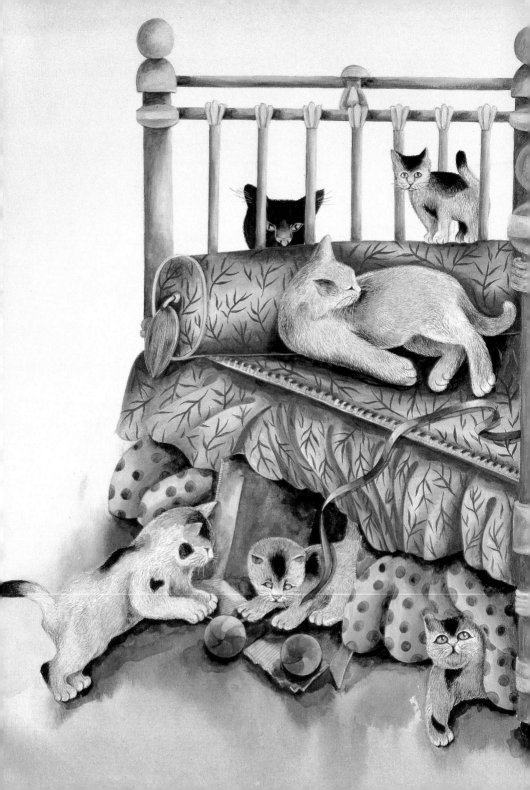

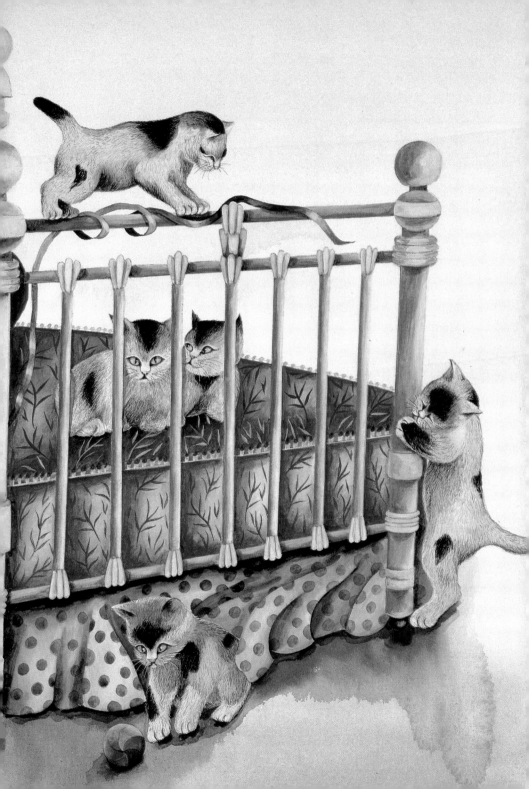

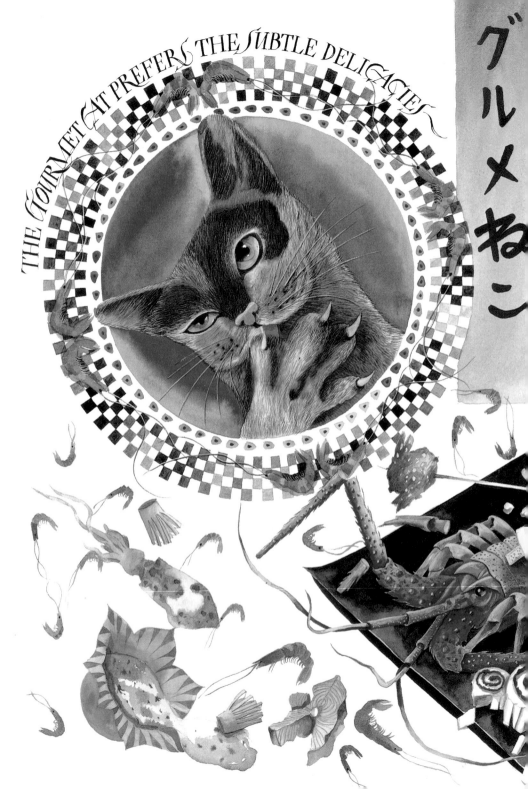

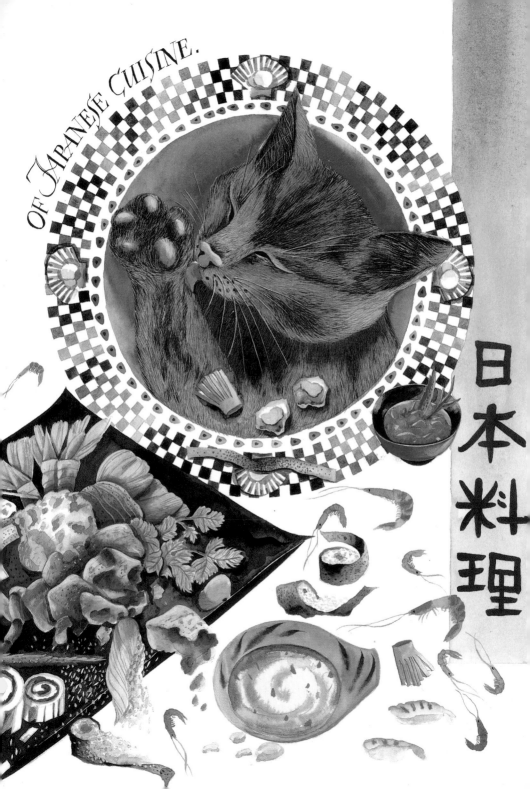

OF JAPANESE CUISINE.

日本料理

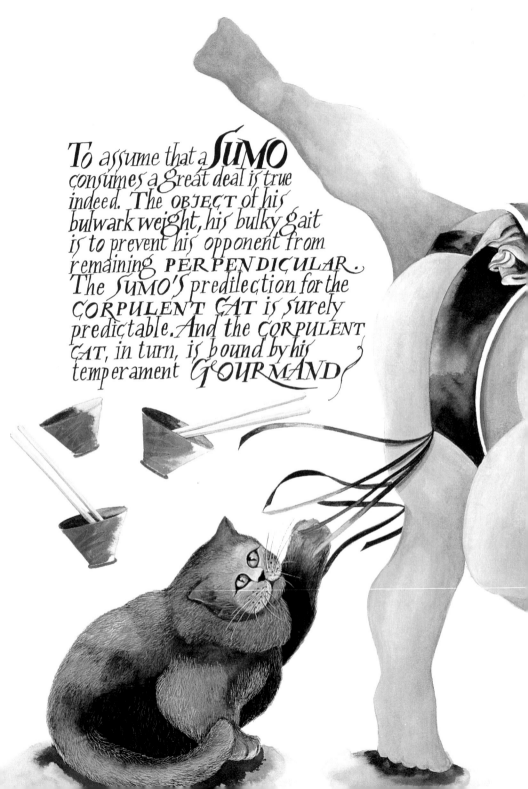

To assume that a **SUMO** consumes a great deal is true indeed. The OBJECT of his bulwark weight, his bulky gait is to prevent his opponent from remaining PERPENDICULAR. The SUMO'S predilection for the CORPULENT CAT is surely predictable. And the CORPULENT CAT, in turn, is bound by his temperament GOURMAND

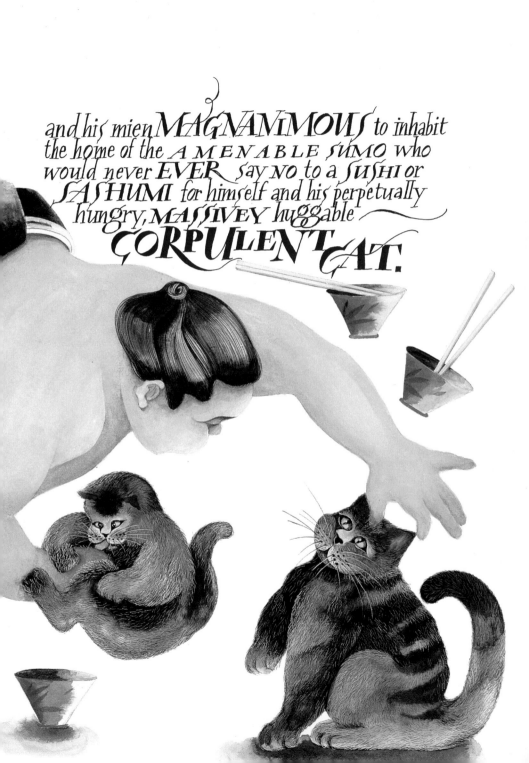

and his mien MAGNANIMOUS to inhabit
the home of the AMENABLE SUMO who
would never EVER say NO to a SUSHI or
SASHUMI for himself and his perpetually
hungry, MASSIVEY huggable
CORPULENT CAT.

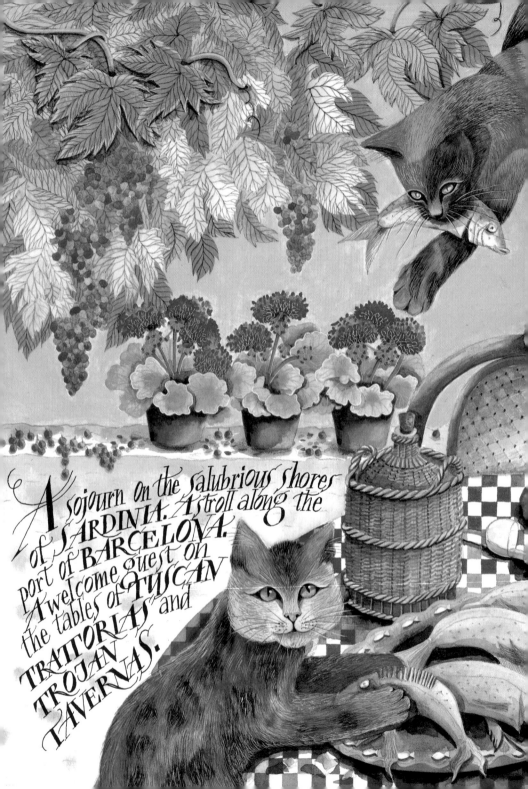

A sojourn on the salubrious shores of SARDINIA. A stroll along the port of BARCELONA. A welcome guest on the tables of TUSCAN TRATTORIAS, TROJAN TAVERNAS.

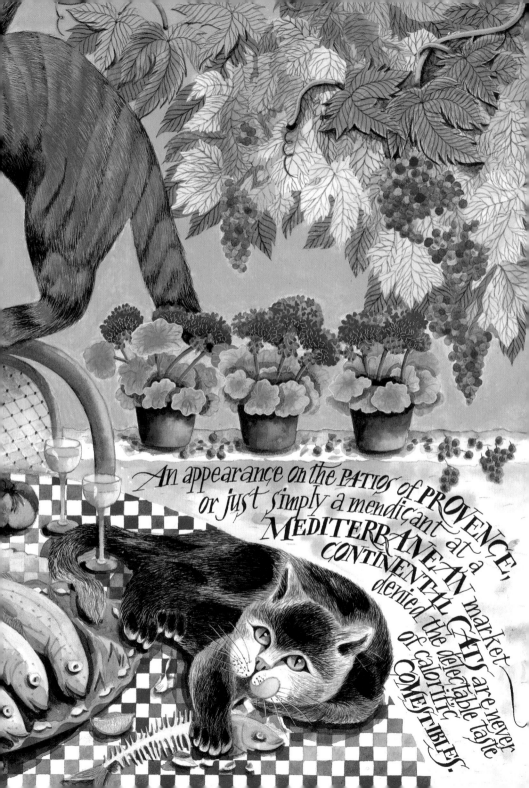

An appearance on the PATIOS of PROVENCE, or just simply a mendicant at a MEDITERRANEAN market, CONTINENTAL CATS are never denied the delectable taste of calorific COMESTIBLES.

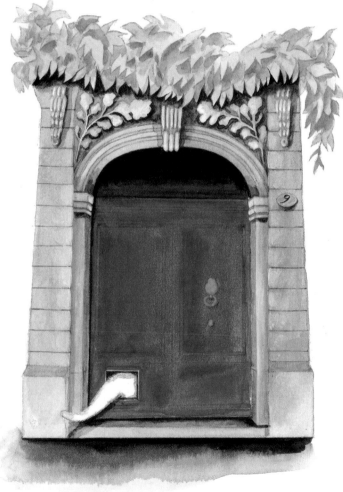

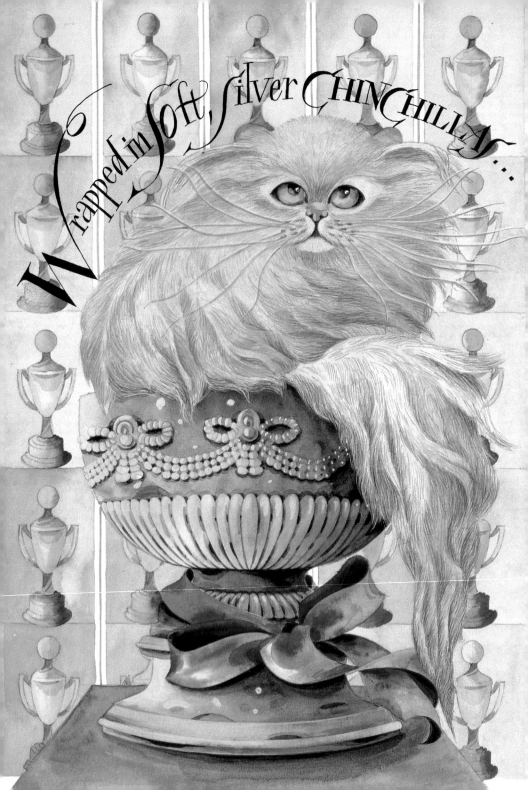

Wrapped in soft, silver CHINCHILLA...

Swathed in priceless coats of the finest, ABYSSINIAN silk. Swamped in RIBBONS, ROSETTES, SASHES and unending adulations. Unashamedly adorned with HAUTE COUTURE BIJOUX, the PRIZE CATS are pampered to Perfection.

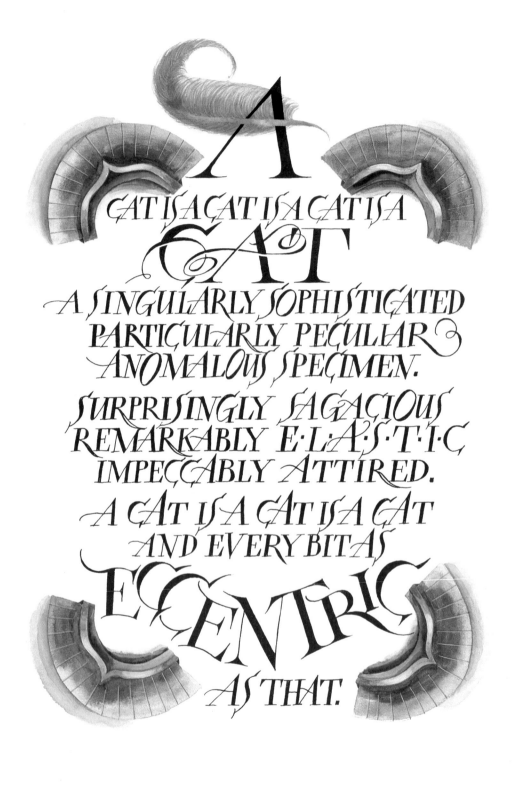

A CAT IS A CAT IS A CAT IS A
CAT
A SINGULARLY SOPHISTICATED
PARTICULARLY PECULIAR
ANOMALOUS SPECIMEN.

SURPRISINGLY SAGACIOUS
REMARKABLY E·L·A·S·T·I·C
IMPECCABLY ATTIRED.

A CAT IS A CAT IS A CAT
AND EVERY BIT AS
ECCENTRIC
AS THAT.

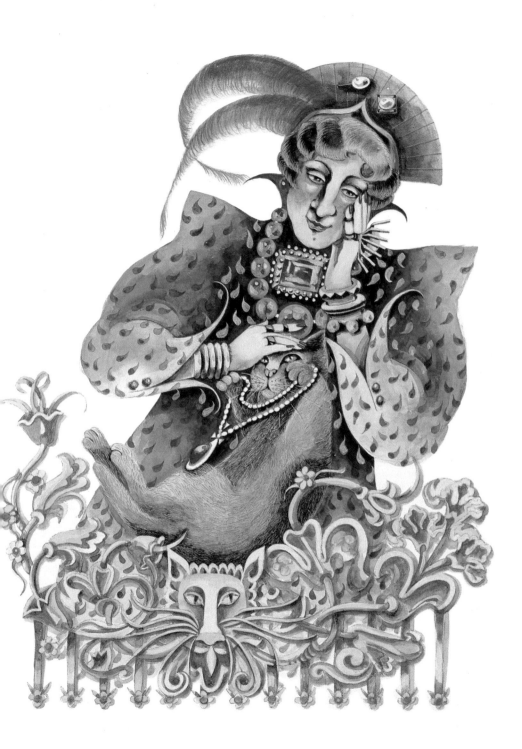

Our speech and our gestures
Are injected with the lethargy
That bears the mark
Of grief.
We focus with liquid eyes
On the places where
You used to sit and sleep and stretch
Your lithe and perfect body.
The chairs and the beds are very quiet
And the carpet is cold.
 All the rooms are silent.
The house is permeated
With the hissing, hollow sounds
Of sorrow and missing.
 We cried rivers.
 We didn't think we would.

Tulips reminiscent of BOSSCHAERT, van AELST and BREUGHEL. Window-boxes luxuriant with VIOLETS and PANSIES embedded in carpets of snowy ALYSSUM. Dwarf NASTURTIUMS, pretty PETUNIAS and buttonball DAISIES in a sea of sapphire LOBELIA. AMSTERDAM—city of FLOWERS; of idle, languid, summer hours, is where all the LAZY CATS gather. Perched on 17th century ledges, sprawled on rooftop TERRACES. AGATE EYES peering through rickety mediaeval windows. Heavy lidded and drowsy, and lame with lassitude, they are lovingly transported on bicycles — comfortably installed in MADE-TO-MEASURE BASKETS complete with VICTUALS to enjoy ALFRESCO.

Fisherman, Fisherman, what will you catch for patient PUSSYCAT? PIKE, a PLAICE, a bucket of MULLET or a treat of tender TROUT? They're craving for succulent SALMON steaks. while he hankers for FISH, but, when PUSSY is peckish, she will relish the scraps of SMELT or SPRAT are scrumptious to a CAT. They're waiting for WHITING; salivating for succulent SALMON. They'd sooner eat TUNA. He would wish for any kind of fresh FLOUNDER. And if all fails, if the worse has come to the worst, fill your empty creel for HAKE, BURBOT, TURBOT and would for COLEY, COD and CARP. though SHE'D sooner eat TUNA while he hankers for HALIBUT. In short, he would refuse not a hearty hunk of HALIBUT. I'm fine smell and savour the flavour if you astound her with slithery slimy, impossibly slippery, irksome EEL.

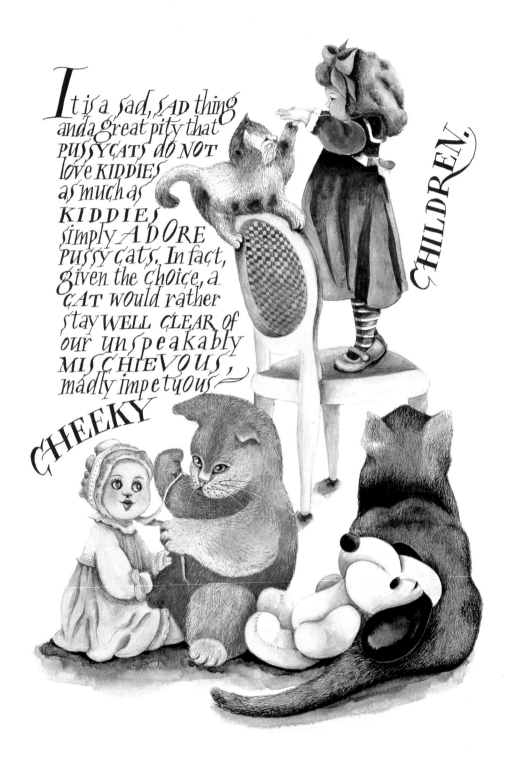

*I*t is a sad, sad thing and a great pity that PUSSYCATS DO NOT love KIDDIES as much as KIDDIES simply ADORE pussy cats. In fact, given the choice, a CAT would rather stay WELL CLEAR of our unspeakably MISCHIEVOUS, madly impetuous,

CHEEKY

CHILDREN.

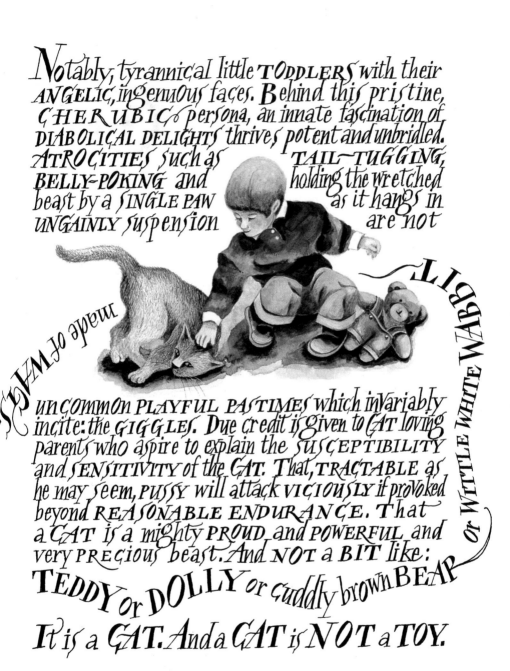

Notably, tyrannical little TODDLERS with their ANGELIC, ingenuous faces. Behind this pristine, CHERUBIC persona, an innate fascination of DIABOLICAL DELIGHTS thrives potent and unbridled. ATROCITIES such as TAIL-TUGGING, BELLY-POKING and holding the wretched beast by a SINGLE PAW as it hangs in UNGAINLY suspension are not made of WAGS or WITTLE WHITE WABBIT

uncommon PLAYFUL PASTIMES which invariably incite: the GIGGLES. Due credit is given to CAT loving parents who aspire to explain the SUSCEPTIBILITY and SENSITIVITY of the CAT. That, TRACTABLE as he may seem, PUSSY will attack VICIOUSLY if provoked beyond REASONABLE ENDURANCE. That a CAT is a mighty PROUD and POWERFUL and very PRECIOUS beast. And NOT a BIT like:

TEDDY or DOLLY or cuddly brown BEAR

It is a CAT. And a CAT is NOT a TOY.

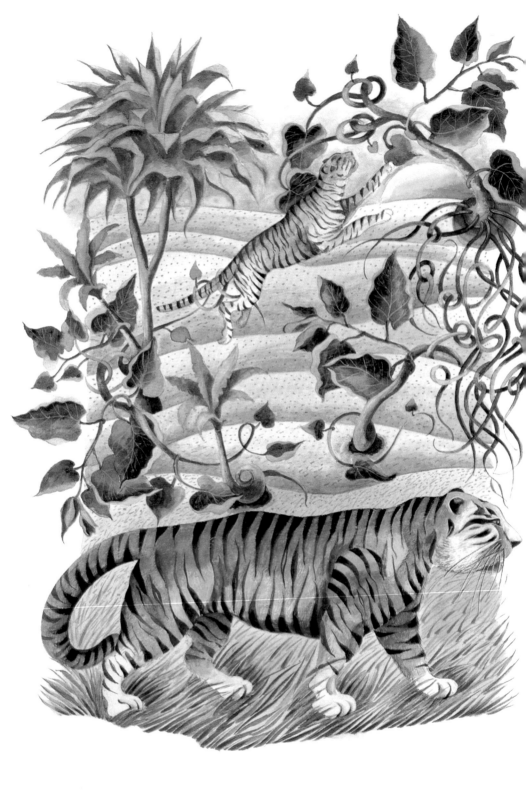

From the Wilds to Wanton Alley. Is he bound for destitution or is he a regal giant in disguise? Beware, take heed of TOBIAS TYRANNICUS TOM as he strides hungrily, menacingly, PROUDLY through the debri, dereliction, disposals and dirt. His instincts are primeval; his claw lethal; his domesticity purely fictional. TOM is the PRINCE of PREDATORS. His purr conceals an ancient, terrestrial growl deep within his feline entrails. Lawless and Lithe and Lascivious, he has the TIGER EMBODIED IN HIS SOUL.

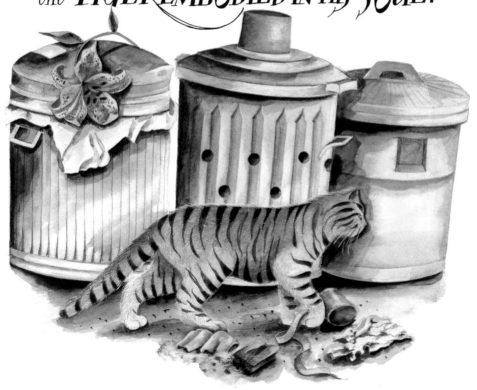

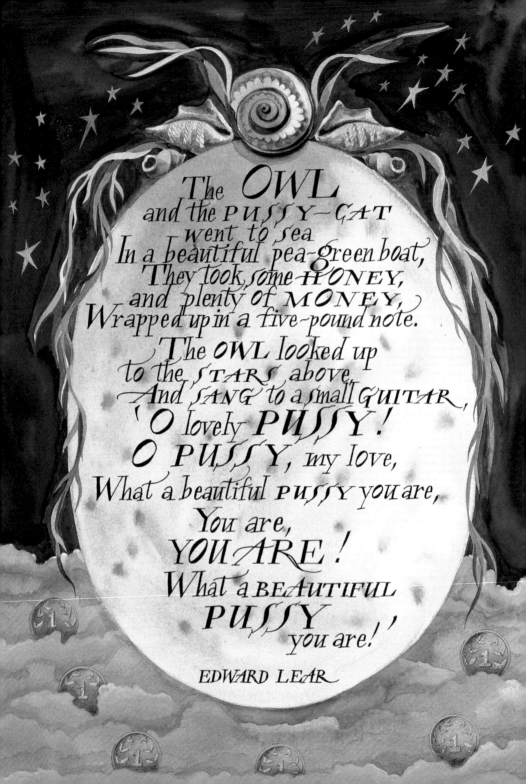

The OWL
and the PUSSY-CAT
went to sea
In a beautiful pea-green boat,
They took some HONEY,
and plenty of MONEY,
Wrapped up in a five-pound note.

The OWL looked up
to the STARS above,
And SANG to a small GUITAR,
'O lovely PUSSY!
O PUSSY, my love,
What a beautiful PUSSY you are,
You are,
YOU ARE!
What a BEAUTIFUL
PUSSY
you are!'

EDWARD LEAR

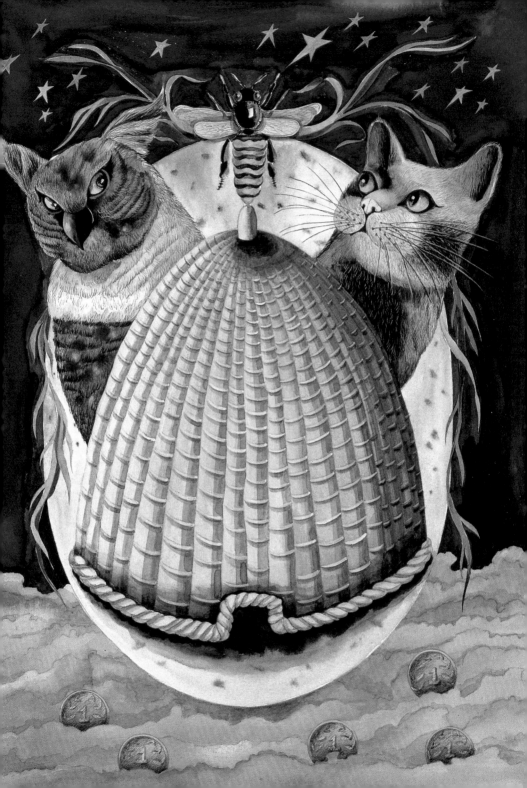

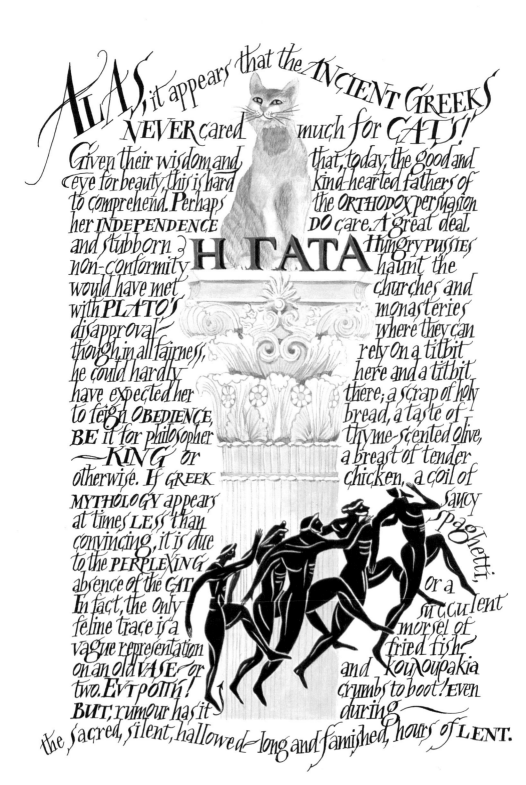

ALAS, it appears that the ANCIENT GREEKS NEVER cared much for CATS! Given their wisdom and eye for beauty, this is hard to comprehend. Perhaps her INDEPENDENCE and stubborn non-conformity would have met with PLATO'S disapproval – though, in all fairness, he could hardly have expected her to feign OBEDIENCE, BE it for philosopher —KING or otherwise. If GREEK MYTHOLOGY appears at times LESS than convincing, it is due to the PERPLEXING absence of the CAT. In fact, the only feline trace is a vague representation on an old VASE—or two. Ευρηπόηη! BUT, rumour has it

Η ΓΑΤΑ

that, today, the good and kind-hearted fathers of the ORTHODOX persuasion DO care. A great deal. Hungry pussies haunt the churches and monasteries where they can rely on a titbit here and a titbit there; a scrap of holy bread, a taste of thyme-scented olive, a breast of tender chicken, a coil of saucy spaghetti, or a succulent morsel of fried fish—and κουνουπακια crumbs to boot! even during

the sacred, silent, hallowed—long and famished, hours of LENT.

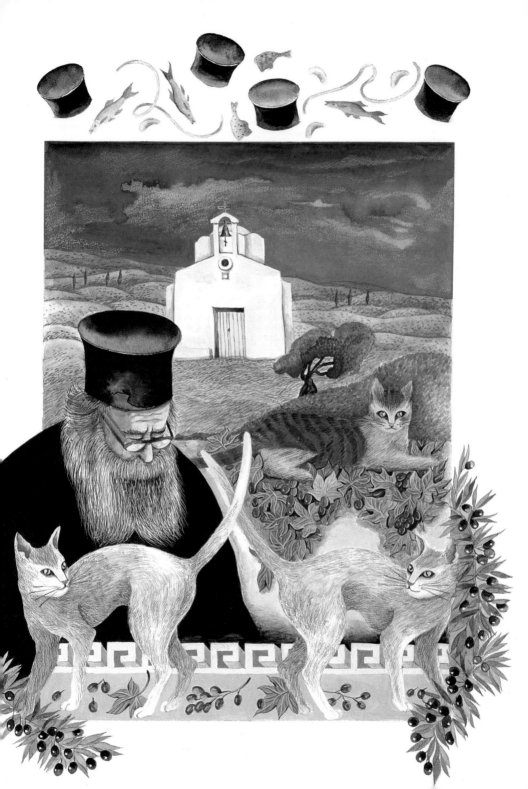

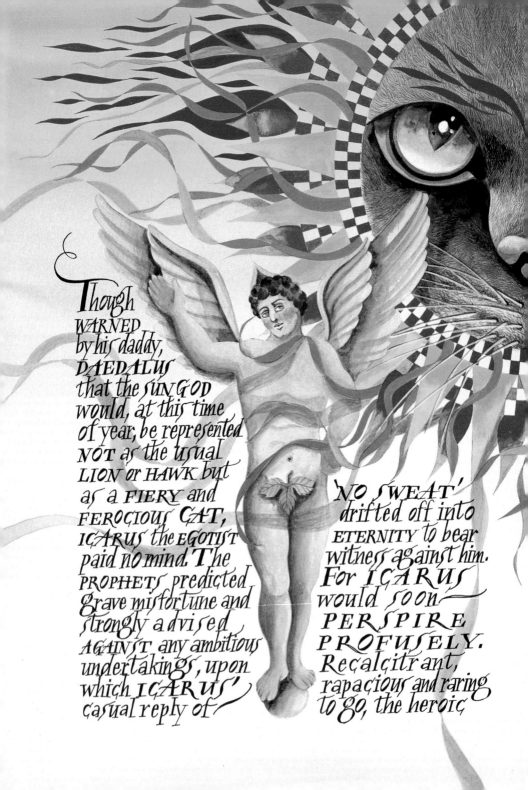

Though WARNED by his daddy, DAEDALUS that the SUN GOD would, at this time of year, be represented NOT as the usual LION or HAWK but as a FIERY and FEROCIOUS CAT, ICARUS the EGOTIST paid no mind. The PROPHETS predicted grave misfortune and strongly advised AGAINST any ambitious undertakings, upon which ICARUS' casual reply of 'NO SWEAT' drifted off into ETERNITY to bear witness against him. For ICARUS would soon PERSPIRE PROFUSELY. Recalcitrant, rapacious and raring to go, the heroic

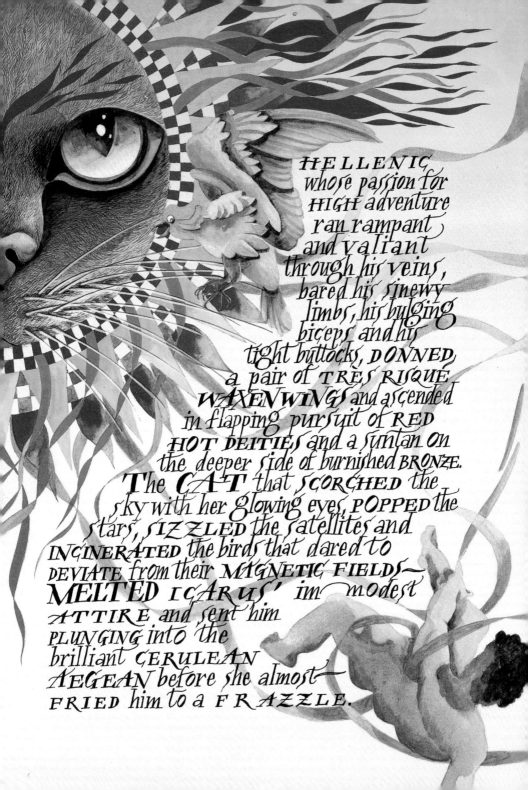

HELLENIC, whose passion for HIGH adventure ran rampant and valiant through his veins, bared his sinewy limbs, his bulging biceps and his tight buttocks, DONNED a pair of TRÈS RISQUÉ WAXEN WINGS and ascended in flapping pursuit of RED HOT DEITIES and a suntan on the deeper side of burnished BRONZE. The CAT that SCORCHED the sky with her glowing eyes, POPPED the stars, SIZZLED the satellites and INCINERATED the birds that dared to DEVIATE from their MAGNETIC FIELDS— MELTED ICARUS' im modest ATTIRE and sent him PLUNGING into the brilliant CERULEAN AEGEAN before she almost FRIED him to a FRAZZLE.

With bloodshed inscribed in his beguiling blue eyes and the speed of lightning in his limbs, he scrambled up the trees, snatched the nests and BUMPED-OFF every baby BIRD born in the spring of 1984. It was DEATH ROW for all weak and vunerable and defenceless WINGED critters within a 2 mile radius of what he arbitrarily claimed as HIS territory: a domain carpeted with feathers. His coat was as WHITE as VIRGIN snow; his disposition as FOUL as DRIVEN SLUSH. He would catapult himself onto birds in mid-flight, shake them senseless, transport them into the house and dump their PEEPING, PANTING, MANGLED carcasses MORIBUND at my feet, while he waited, impatiently for approval and due rewards. No amount of castigation could temper the blatant GLASNOST of his gruesome taste for tyranny and torture. No punitive procedures reformed his FELONIOUS ways. Consolation came in the knowledge that EXTERMINATION of the BIRD POPULATION was every healthy CAT's idea of FUN and RECREATION. But, OSCAR BABOSCAR was of mental stability: DUBIOUS; of CHROMOSOME-count: SUSPECT. It wasn't until EX-MILITIAMAN cum FOREST RANGER alias BREEDER of dulcet-toned SONGBIRDS stood at my gate with his WINCHESTER 44 calibre pointing at OSCAR who emanated INNOCENCE

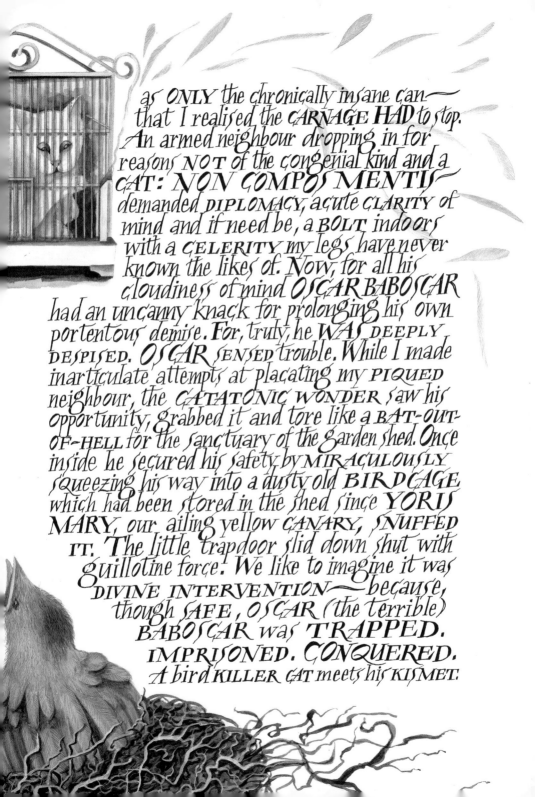

as ONLY the chronically insane can—
that I realised the CARNAGE HAD to stop.
An armed neighbour dropping in for
reasons NOT of the congenial kind and a
CAT: NON COMPOS MENTIS—
demanded DIPLOMACY, acute CLARITY of
mind and if need be, a BOLT indoors
with a CELERITY my legs have never
known the likes of. Now, for all his
cloudiness of mind OSCAR BABOSCAR
had an uncanny knack for prolonging his own
portentous demise. For, truly, he WAS DEEPLY
DESPISED. OSCAR SENSED trouble. While I made
inarticulate attempts at placating my PIQUED
neighbour, the CATATONIC WONDER saw his
opportunity, grabbed it and tore like a BAT-OUT-
OF-HELL for the sanctuary of the garden shed. Once
inside he secured his safety by MIRACULOUSLY
squeezing his way into a dusty old BIRDCAGE
which had been stored in the shed since YORIS
MARY, our ailing yellow CANARY, SNUFFED
IT. The little trapdoor slid down shut with
guillotine force. We like to imagine it was
DIVINE INTERVENTION—because,
though SAFE, OSCAR (the terrible)
BABOSCAR was TRAPPED.
IMPRISONED. CONQUERED.
A bird KILLER CAT meets his KISMET.

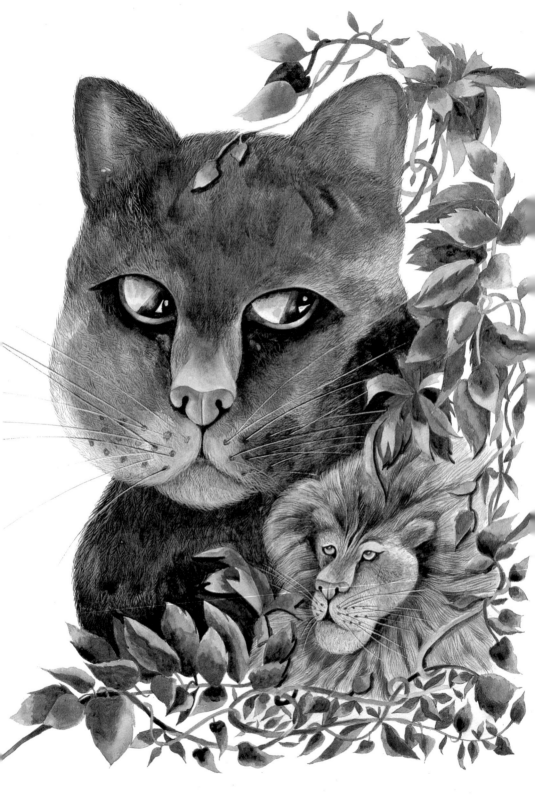

For some,
PUSS
is the JEWEL
in the CROWN.
For many,
he is the HIGH
and MIGHTY
E M I N E N T
member of our
SOCIETY
THE KING.

Thankyou, thankyou
GRUB STREET
Thankyou
ROGER HAMMOND
for sensitivity and careful criticism.
Thankyou
JOHN DAVIES
for patience and optimism.
Thankyou
HANS BOCKTING
for support and stability.
Thankyou FRIENDS
for smiles and superlatives.
Thankyou
PHOTOGRAPHERS of CATS
for,
when asked to POSE,
PLURK
presented me with her BACKSIDE.

Thankyou ROBERT SMITH.

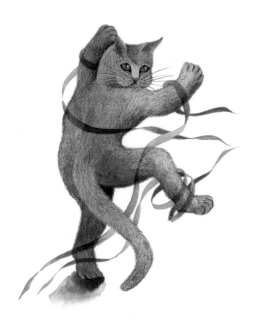

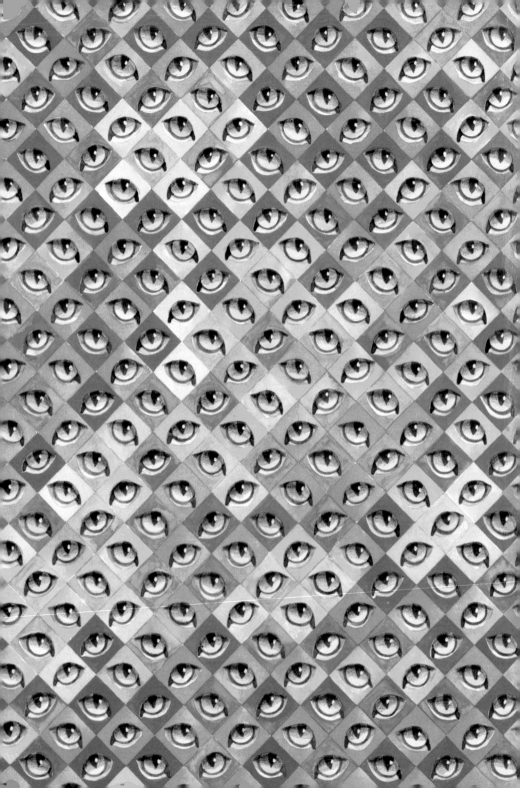